ANCIENT
ART OF
DOWSING

BY
DUANE OSE

To order additional copies of this book, contact:
Xlibris
1-888-795-4274
www.Xlibris.com
Orders@Xlibris.com

Ancient Art of Dowsing

With Instructions for Today

By the Dowser
Duane Arthur Ose

Dowsing is an ancient method used for locating, measuring, and mapping of the invisible energy fields of objects on, overhead, or beneath the Earth's surface.

Dowsing objects and other energy sources are detectable at any depth. Unlike the expensive ground penetrating radar, the modern high-tech method is limited to shallow depths unless nuclear energy is applied. Therefore, at a nominal cost to any individual, why not learn to *dowse?*

I will henceforth refer to beneath-the-surface objects and their emitting energy fields to as targets.

Targets also are the voids absent of matter. Even the filled excavations are targets, whether they were made a million years ago or last night and with or without having anything placed within them, such as bodies power cables, water pipes, septic tanks, land mines, previously undetected bombs, telephone cables, gas lines, coffins, vaults, prehistoric or new bones, drain tile, ancient burials, treasure chests, well sites, earth-covered outdoor toilet holes, dumping sites, culverts, caves, tunnels, and animal dens; the list is Including the unknown water veins that can be found beneath the surface.

Some very exciting profitable targets came into being while the earth was forming, that began by the flowing superheated gaseous liquids. Those flowing liquids stultified, cooled to become solid mineral veins found in rock. The field of energy made by those once flowing liquids did not die.

The Prelude to Dowsing
The invisible Fields of Energy

Bats, while in flight in total darkness, never slam into walls, objects, or another flying bat.

Here is why as far as that goes: Each one of us, with practice, while in a dark room with live moveable bodies or fixed-in-place objects, can move about without touching any body or object and still make it from the entrance door to the exit door.

With a little practice, we would learn to sense the emitting energy of the objects without touching them while slowly moving to the exit door. Each object or wall has an energy field and can be felt or sensed usually within inches of the face or the body. The name for this field of emitting energy is called the aura.

Some people's auras can even be seen by what looks like a halo extending from the body. Visible halos vary in size, and some are even seen in color. Having a visible halo is most common to a person with an outgoing personality that is filled with robustness and is someone who is comforting to be in the presence of. Halos are not seen by everyone. Only a few have this gift.

Bats and other mammals have highly sensitive sonar that detects emitting energy (aura) from the surfaces of all objects whether the objects are in motion or fixed in place. This mammal sonar is learned from birth due to the habitat it is born in. Each bat has its own energy field. In the case of a bat's energy field, when it abuts another energy field, which is fixed in place or in motion, one or both opposing energy fields move apart before the two physical objects would otherwise make contact.

Energy fields can be compared to that of magnet iron bars that have negative and positive polarities. Negative pushing negative, positive pushing positive and the opposite polarities attract. Dowsing too attracts, detecting the fields of energy of targets beneath the surface and pushes away from auras of objects on the surface. Detecting of an aura is the same as or compares to sonar in water or by radar of air space and in outer space.

In fact, everything, i.e., matter, has an energy field emitting 360 degrees. Matter of whatever size of the whole consolidated form is encased in a fuzzy kind of invisible cocoon of energy.

Atoms make up the molecules in matter. These molecules then results in intermolecular forces. It is an " electromagnetic force," a "free energy," an energy that does not die.

[Thanks to my Echo, Minnesota High School science teacher, Mr. Stanley Roberts.]

With the science of the invisible nature's energy emitting fields explained, I begin the instructions of the tools I have come to know and use.

Contents

Chapter 1

Willow Dowsing

Perhaps the earliest tool used is the willow V fork with a long stem. The bark may be left on or removed. If not a willow, another fresh green V-fork tree branch can be used. The branch works best if it is slender and limber.

The willow V fork was used primarily for locating a water vein for the homesteaders, which was a common practice. It was not until a homesteader had found water, which then is where the home site was to be build. Locating water was the first priority, and after the well was dug, it was followed by the house and barn.

A fresh willow branch with the bark left on works best for me. Carefully sawing off the V ends must be done in order to keep the bark from detaching from the wood. The single long stem should be three feet in length. The V ends should be sawed two feet back from the stem. Shorter willow forks work too, but the long and slender forks are the most sensitive.

The purpose of keeping the bark intact on the V ends is about to be explained in the following paragraphs:

Grip firmly the ends of the V like you would the rubber grips on handlebars. Hold the forked willow pointing forward horizontally. Be sure the grip is firm and tight, not just tight to hold it but very tight. Slightly apply side-to-side tension, spreading apart the V but not so much as to split the V.

A water vein is where the willow branch dowses it. Water veins are not always where you would want them to be. There may not be a water vein anywhere near. The dowser will have to keep looking until a vein is found.

Upon the chosen land you wish to search for water or would like it to be, walk holding the willow branch forward at a slightly slower than a normal pace. All the while, be conscious of holding the willow stem horizontally. If and when the long stem dips down, you have a target. First, be aware it is an unknown target at this time. It could be most anything.

Now that a target is located, continue locating the edges of the target by backing away, and move right or left a few feet. Then move forward, locate, mark, repeating this until you have marked out the outline of the target. If the target is long and meanders like a riverbank, you have located a water vein.

The willow stem will tend to point downward (dowse). Try to continue to hold the willow stem

level yet still moving forward at a normal walk and firmly tight. If the vein is strong, the long stem will self-dowse down, dipping to the ground. The bark of the willow's V ends will remain in place in your hands, but the wood within the griped cut ends will break loose from the bark. This ripping loose of the bark will feel like a snake squirming in your tightly gripped hands.

That is a creepy feeling. I like doing that every once in a while for fun. This action always amuses me and impresses those around me, so much so they too all will want to dowse that very minute.

Once the bark has been loosened, continue as before, but you now know you have seen and felt the unseen energy force, having witnessed a phenomenal event. The bark now can be removed entirely. This willow fork can be used again. When doing more dowsing (experience), you will still feel the willow move on its own.

Now work the area over to determine where a well will be best. Depending on the type of ground and the depth to the vein will be the determining factor of the kind of well system needed. You may only need to pound in a sand point or dug a shallow well or a drilled deep well with a submersible pump. (Finding the depth is explained ahead.)

To find the width of the vein, back up and walk forward again. But this time, as the willow is drawn down, continue to move forward until the willow is no longer being pulled by the target's energy force. This nonaction means you now have passed to the other side of the target or vein. This then is the width of the vein.

You may ask: Is it the willow or the feet that is doing the detecting? The answer is it is the willow, not where your feet are.

Bobbing

Bobbing of the stem occurs on its own. Now read carefully because this bobbing measures the depth.

Count the number of bobs that the willow stem makes. That count is in one foot increments and is the depth to the top of the target, not how deep the target itself is. If you drive a solid pipe down beyond the top of the target, you may go through the target and miss the water's source or thickness of the vein. Instead, use a sand point and check for water after the point has been driven into the top of the target.

I am sure to always inform a well driller as to the depth of the top of the water or as in some cases they have missed, not by going to the side of a vein but by going through the vein on down to deep.

Continuing back to the bobbing, bobbing will begin slow then increase in speed then slow to a stop. To restart the bobbing, step back a few steps then step forward again. Count each of the bobs each time the bobbing restarts and you will find the number of bobs to be the same. But be careful as the bobbing will restart by its self, and you will get a false count, so know each time when the initial count has stopped.

In the early days, about thirty feet was the average maximum depth of a hand-dug well. Nowadays, any depth can be drilled. But unless it is a flowing vein, still water can be bad to the taste. So deeper is not always the best water.

A water vein could range from one-foot wide to up to twenty feet or more. Wider means a strong water source. Most veins are made up of what is known as water sand, a small in size pee rock, black and white pebble sand. Most veins are made up of sand drifts while the earth is forever changing. The surface water settles into these sand veins or fractured rock.

My comment on the use of the barked willow V is this: It is not my preferred tool, but I am intrigued by the way it works.

Chapter 2

Dowsing Tools

Long steel bar

A bar could be a pry bar, even an axle shaft or a sawed-off length of bar stock from a steel supplier. The length should be no less than four feet and of approximately three-fourth to one inch in diameter.

A five-foot bar is my preference. But the length and weight depends on the dowser. The dowser must be able to hold it comfortably in a special way for long periods while walking.

In using a bar for dowsing as in all dowsing there is no depth limit. Instead of bobbing, the bar being balanced in that special way will tip over at either end, the end that is over the edge of a target and remains tipped while over the target. The bar will come back to balanced level again when not over the target.

When using a steel bar, the target is not water but an oil dome. Yes, *oil dome.* This dowsing bar tool is no longer used and has been replaced by the extensive expensiveness of seismographic high tech of under-the-surface three-dimensional mapping while above the surface. Because of this, there are no longer independent small companies called wild caters. Wild caters were in the business of exploration and the drilling of oil wells. For the wild caters, it has become too costly to work independently because of the high-tech exploration and all the added regulations. Argo big oil has taken over the industry.

Like today's seismographic mapping for locating the best consolidated place to extract the oil, so it was when the use of the long bar dowsing was commonly used. The high-tech method of exploring vast land areas and mapping for oil has caused the oil dowsing to become a lost art, of which the people nowadays perhaps never heard of.

When a high concentration of oil source is located, it is not one oil well or pump that is set up but several on the same concentrated location. This is done for the convenience of storage and transportation.

I myself have done the bar dowsing years ago in North Dakota for a rancher that was surrounded by oil-producing neighbors. But the owner, with his one son on a large horse and cattle ranch, was afraid to sink all his money in one exploratory well; knowing a wild cater would be paid whether or not oil was found.

I was eighteen and invited to hunt for free on their land. Then one evening, the topic of the oil-producing neighbors came up. During supper, I brought up the fact that I had experience in dowsing. "If I may, I would like to try by using a bar that I was told how it was used. Let me try to see if I can get an indication."

The next morning, the rancher handed me a pry bar that they used in removing large rocks. I explained that it is in knowing how to use the bar that is the key. The bar has to be balanced on closed clasped hands held close to the chest. Then while supporting the resting balancing bar on the base bone of the one thumb that is on top the clasped hands, this bar is resting from left to right across in front of the chest.

Then walk resting the bar in that fashion on the grass rangeland until either end of the bar tips on its own. If the bar tipped, there was an oil pressure point thousands of feet down. The find had to be mapped, outlining the location before any decision of drilling could be done.

With the bar resting on my thumb, I began by walking in a straight direction from the ranch house with the ranchers paying attention to the bar. I kept on flat ground for about half a mile. Then as I neared a high grassy hill, I began to pass by it for ease of walking without stumbling. To keep the bar balanced was a bit tiring when, suddenly, the bar wanted a piece of that hillside; the bar began to tip. Dowse.

Like before in my other types of dowsing, I backed up and made a few more approaches. Each time, that bar definitely dowsed toward the hillside. I told them to mark that spot and I would continue on by walking to the side to see the bar come back to level, and as I moved the other way, it would dowse. In time, I made my way around the oval-shaped hill with a trail of marked dowsed spots. I then told the rancher to try this and see for himself. He did, and it worked for him as well.

I then took the bar back to the flat area of land to balance the bar. This time, I made a scratch mark on the balancing point of the bar. We rested by having some cool lemonade. Then balancing the bar, I went on up and over the hill. It was a battle to keep that bar on my thumb, a battle that I lost a lot. The bar would slip off, but I knew where the mark of the balancing point was. So I knew the bar was dowsing. I could feel the bar moving on its own. It was like a person was pulling it off my thumb.

The next year's hunting season, I went a bit out of my way by the ranch on my way to Wyoming and saw two big tall black oil tanks with an oil pump pumping on that hill top.

Pliers

Large pliers are hardly dowsing tools that are of any reliability. But I have had them work for me.

My father first showed me this on the farm when we were installing drain field tile lines. In order to connect to an existing line to attach a branch line, I would dowse for the existing line with my dowsing rods that I will explain in detail latter. But this time, he opened the tractor's toolbox and brought out large pliers. Dad partly spread the pliers open like a V then, with his thumb and forefinger on each hand, held the ends of each handle.

Dad held them half open horizontally and walked over the suspected area of the tile line. The open pliers moved and pointed down to where the line was buried. Then I too had them work for me as well.

Not just anyone will be able to make the pliers work without a lot of experience in dowsing, I am sure. But please try this at some point in your dowsing.

Any two-of-a-kind L-shape-fashioned rods

They can be electrode welding rods, straightened-out metal coat hangers, bronze bare welding rods, and other metal rods.

How the L-shaped rods are used will be in chapter 3.

Chapter 3

My Best Dowsing Tool

This tool is made from two 3/32-by-36-inch bronze bare rods, which can be purchased from a gas welder's supply store.

By bending a six-inch ninety-degree bend on the one end of each rod, they then become dowsing rods. A dowser with these two dowsing rods is then able to locate underground targets. No matter what the depth it is to the target.

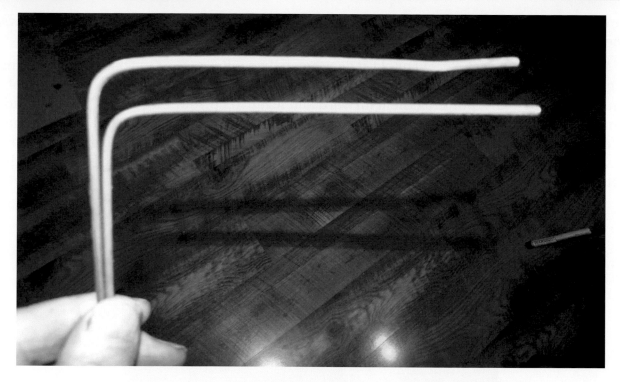

There are three uses of a single rod, and they will be explained in this chapter:

1. To detect auras. Auras are the energy fields of the objects aboveground.
2. The one rod will align itself with the energy's flowing course of the targets beneath the surface.
3. For measuring of the depth to the top of a target.

The Use of Two Rods

These are the instructions of the combined use the dowsing rods.

For the purpose of proper practicing and testing, work over a known target. Targets can be culverts or an interment plot in a cemetery, which are two types of examples. Just as long as you know where and what the practice target is in order to confirm you're learned dowsing abilities.

If you wish, choose a private place to test yourself until you become confident in dowsing. Beginners often look or feel like fools, and this could be a discouraging factor. Perhaps this is why

some people say they can't do it while others take right to it with no problem. To become a dowser, it helps to have an open mind in order to be sensitive to the energy-sensitive dowsing rods.

Select a known target. Recent or old, it does not make a difference. Stand back from the known target selected. Hold the six-inch ninety-degree-bent bronze bare rods as you would a pair of six guns being held apart, pointing them forward and level. Keep your elbows snug to your sides, guns (rods) parallel pointing at the imaginary guy down the street facing you but with one major difference, which is in the gripping of the six-inch bend. Place your one little finger of each hand toward your body's side of the rod. This enables you to not having to grip tight the rods, which then allows them to move freely while being held balancing parallel and at a horizontally level.

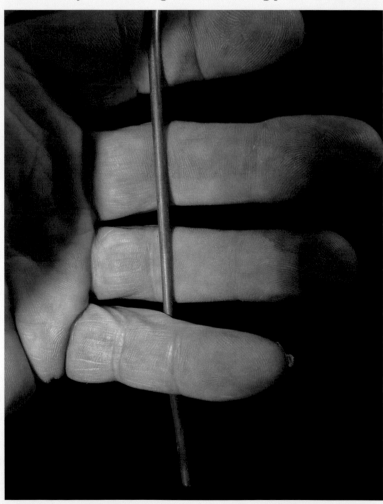

If you wish, you can place your thumbs on top of the bends of the rods to hold them lightly in place for they do need to be able to move. Practice this gripping and balancing before you proceed. Be mindful not to point them downward or upward but maintain them level.

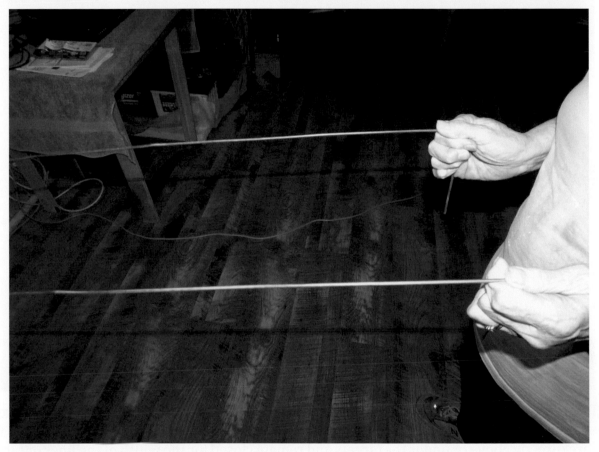

Walk at a normal pace without stopping to the known target. The rods will begin to cross as the rods are just above the edge of the target. Continue moving. The rods will fully close pointing toward each other when the target is fully under the dowsing rods. Continue moving. The rods will begin to open upon reaching the other edge of the target and will be completely open pointing parallel forward after the rods have passed the target.

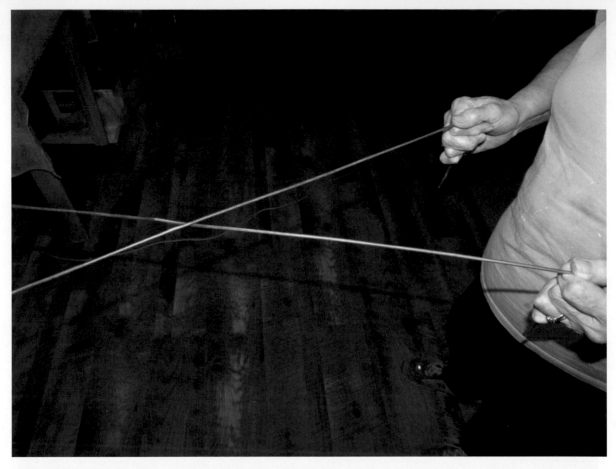

Targets are also found and detected at unlimited heights above the rods. These targets are the lines of power cables, phone lines, or just a plain wire. The dowsing rods will close for the time they are directly above or under the targets and remain closed for the width of the lines or targets.

It should be noted that it is the rods that are over the target and not where your feet are that the rods move. Do this dowsing several times until the pronounced feeling of the rods moving on their own is well realized.

Once that stage of dowsing works well for you, you can approach the target from all directions to locate the edges of the target, whatever the shape of the known target is. Remember, as the rods begin to cross, that is an edge of the target.

Okay, so what if you locate an unknown target? Dowse then for the edges of this new target.

Dowsing the edges will then give you an idea of what it could be by mapping it, drawing a picture of its outline or its shape.

It would be well for you to know how deep it is to the target in order to narrow down the possibilities, having then more of an idea what it may or may not be. To measure the depth, one rod is used. This portion of instruction can be tricky but not difficult, so pay close attention to this next stage.

The Third Use of One Rod

Select a three- to four-foot length of wrapping cord or similar in size cord; make a half-inch loop knot on one end of the cord, a large enough loop to make a synch tight loop for the cord to grip the rod for quicker reuse and for the ease in attaching the cord versus tying a knot each time needed.

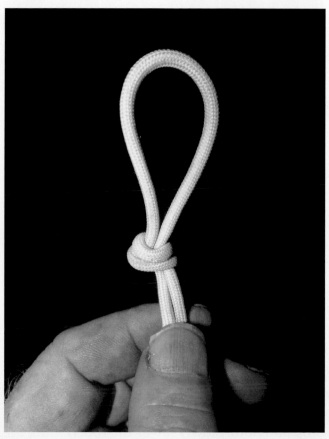 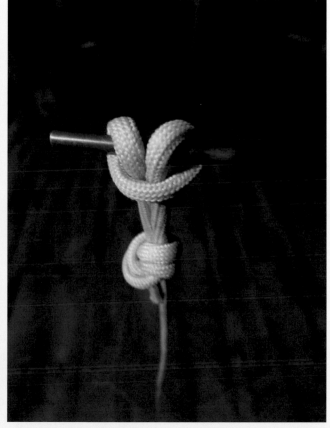

Hang the cord from the tip of the level rod that is held at waist height. To begin with the cord hung on the tip of the rod must be long enough to reach the ground. Then use a very small double-blade pocketknife for simplicity. Open both blades. The smaller of the two open blades is then clinched closed on the cord at a height just above the ground. Hold the rod horizontally, with both hands firmly gripping the flexing rod in order for it to remain somewhat in place and steady, with the long blade pointing approximately two inches above the ground or debris. As more experience is gained, this dowsing will become automatic.

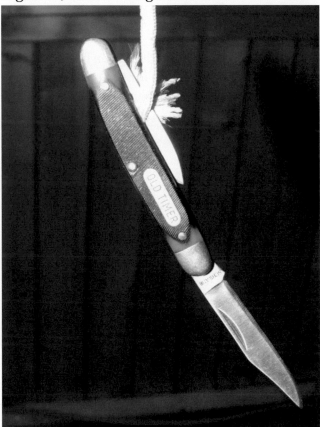

Any small weight will do in lieu of a pocketknife, such as a half-ounce lead fishing sinker or bolt. Whatever the light weight used, it will sag the 3/32 long rod.

An important fact that I have discovered is *do not stand* with your feet directly over the target or the measuring will not work, but instead, place your feet off to the side of the *target*. Hold and dangle the rod's cord and weight over the target. Stop and hold. Slowly lower the rod, resting the

knife or weight on the ground, relaxing the cord. This, for whatever reason, zeroes the cord, and its attached weight, much like a stopwatch, is set back to zero.

Next, ever so carefully raise the rod with the dangling weight until it is above the ground, approximately two inches. Stop at that point. Hold the rod still gripping it with both hands and wait. In a moment, this rod, on its own, will begin to bob. Be ready to count each bob. The rod will first begin to slowly bob up and down. Begin the count on the first bob, and keep counting until the bobbing stops. Count the bobbing, the ups or the downs, your choice.

To restart, lower the rod, resting the cord's weight again on the ground to zero it. Again, raise the rod and weight two inches above the ground. Hold the rod still and wait for the bobbing to begin. Count each bob. Each time the bobbing count is done the count will remain consistent. Each bob is equal to one foot. The bobbing count is the number of feet it is to the top or to the target. The bobbing does not measure to the target's bottom.

Always double check the count, perhaps even several times. Do not try to figure out how the count remains the same. It just does.

"Because something works and it cannot be explained does not mean it does not work." —DAO

Note: Do not fight the bobbing. It is possible to forcibly hold the rod, keeping it from bobbing.

Three things you must remember about this: One, the weight has to be off the ground; the bobbing should be free and unrestricted. Two, the bobbing's speed will begin slowly and then speed up. At midway to the target, the bobbing will begin to slow. Then bobbing will slow to a complete stop. Three, the bobbing can restart on its own.

Be aware of this self-restarting or there will be a miscount of the bobbing. Each time after the initial bobbing stops, zero it, and then restart to recheck the count. The depth could be shallow or hundreds of feet.

The Second Use of One Rod

After having located a target and measured its depth, it is time to use the one rod without any attachments. This is for the purposes of mapping and homing in on the alignment of the target.

Start first by standing away from the target, holding the one dowsing rod waist-height level pointed toward the target. Walk toward the target. When the rod is becoming over the target, the rod will turn right or left. Continue walking but following the tip of the rod. If the rod turns as you are walking, continue to follow the rod's tip. After a short distance of following the rod as a pointer, mark the ground in some fashion for reference.

Then after the ground has been marked, relax the rod, pointing it down, and walk at a right angle a few feet away from the course walked.

Now hold the rod level; point it in the direction of the marked ground. Walk back to that mark. If the rod again turns as it had pointed before, the target is still there, and the rod is yet on, pointing the course of the flowing direction of the energy field. Then simply continue marking that line. This line could eventually be hundreds of yards twisting and turning. But this is the target, however, wherever it may lead. Every so often, check to know that you are still following the target.

If, however, the course has been lost, which is normal until after hours of practice, relocate the target by using the two rods, and then begin again with the one rod.

These targets could be water lines, power cables, oil pipe lines, gas pipe lines, water veins, or other flowing directional energy. By doing the mapping of the outline of the target, finding its course and length, than by measuring the depth, a dowser now has a mental picture of the target. There by the dowser can determine what the target is. A dowser knows that water and sewer lines are usually buried 6 to 8 feet with other service utility lines are even shallower. Larger cross-country transport pipe lines maybe ten to fourteen feet beneath the surface for safety reasons. Phone cables, power cables, or other shallow-placed utilities may be in straight slender lines from the house to a utility pole.

The First Use of One Rod

All objects above and beneath the ground's surface have an energy field. The emitting energy fields of objects above the surface are auras.

Again, hold the rod the same as before. Point the rod at any solid object, such as a tree trunk, boulder, or even a person. Walk forward at a normal pace pointing the rod at the center of the object. Walking to slow, only inching along, will not work. Think of it like this: An aura, an invisible energy field, is like a shield. A shield will deflect a fast incoming object but not a slow moving pointing rod.

The quick-approaching dowsing rod will be deflected to the right or left of the center of the object. This deflecting to the right or left depends on the path of least resistance. It would be best to practice this first on an inanimate object then a person for safety reasons. Auras are of different thicknesses. They may vary from one inch to three inches. Small objects have smaller auras. Large objects have larger auras.

The width of auras of persons of the same size may vary. It has been my experience that a robust, happy, fun person's aura is more pronounced.

Water Veins

Water follows the path of least resistance. These below-the-surface pathways then are water veins. Veins can be of any width or length and could have branch lines. Water veins flow like that of rivers, streams, or waterways but with two big differences: (1) A water vein can be of any depth. (2) The water flows through various types of materials, such as fractured rock, sand, pea-size sand or what I call water sand. Water sand is a mix of black or white round pea-size stones. This water sand is known for its high water content.

But like streams on the surface, water veins can have waterfalls that drop to a lower level. Some veins flow to a drain, disappearing into the center of the earth. Underground water drains are extremely rare. While using one rod in tracing the course of a vein and the rod goes into a turn, turning in a tight continuously revolving never-ending spiral, that is a drain. A drain is the most ideal place in which to put in a well because the vein will never be missed by drilling through going to deep. This vein at this drain point is collecting water and is falling straight down, never running dry.

Water can also be pushed upward, bubbling to the surface or like a fountain, often to the top of a hill or to higher ground. One rod there too will also be revolving in a tight spiral, but instead of a drain, it is an artesian source, and the water will be close to the surface. Wet ground and plants that like lots of water will be found there. Dowse for the depth; it will most likely be near the surface.

I conclude with some of my Experiences and comments.

Dowsing a pail of water or any open water, as in lakes, rivers, or water puddles, does not work. A thirsty horse may smell the water, but a metal rod does not.

Even with snow covering the ground, dowsing still works quite well and perhaps better. I have found early spring and late fall, when the vegetation is not high, are the easiest months for dowsing. Whatever the season is or local at any time, dowsing works for locating all targets.

Water veins have the best water for consumption, and they do not need to be deep. Water veins are most likely pure after being twelve feet down at some point, and veins can exit, which is known as a spring. Contamination can occur after the spring water touches the surface materials that are being exposed to germs or a tiny parasite called *Giardia lamblia.*

For the purest water, tap into the exiting flowing water, not the pooling of the water. Standing water should always be purified before drinking in cold climates or in warm climates, winter or summer.

Most well drillers have maps that inform them of what the water table is in a particular area but not where the water veins are. Deep wells of hundreds of feet are most often contaminated by billions of years of rotting plants and animals, of what I refer to as an oil and natural gas base mix, for gaseous stinking swamp water. The best water is in the flowing water veins. Standing or still sub-terrain water is never as good.

The comments of some drillers are "We drill until we hit water." Some ask me to dowse for the best water, while other drillers do the dowsing themselves.

On more than one occasion, I have by the computer here in Central Alaska on Ose Mountain instructed how to find water by dowsing.. One lady e-mailed me asking for help because the driller had not found water at the depth of two hundred feet. After some e-mailing, the woman located a vein and was able to measure the depth to the water. The driller reset his drill rig and on the very spot at the depth she had measured struck water for their new house site. The water was not where she had wanted it but instead one hundred feet away.

I love to dowse after researching the history books or other saved documents in the location of old wells, foundations, basements, garbage dumps, outhouses, family burial sites, abandoned cemeteries, village sites, town sites, and the lost or forgotten containers of hidden buried money.

For thousands of years or more, humans have lived on this planet leaving their mark that had in time disappeared. With dowsing rods, I have located several village sites and individual burials or in some cases mass graves.

Dowsing is noninvasive of any soil disturbance yet able to locate, record, and mark lost, covered, or buried objects for the history books.

Dowsing can be used for military purposes too in finding deep hidden ammo stores, bunkers, deep tunnels that are used for infiltration by enemy terrorists and material or for planned attacks. In locating such targets, they then can be destroyed from above in many ways, securing the safety of the civilian populace and the military. Because Dowsing has no limits of underground targets, I am thinking of Israel when writing this paragraph.

I predict that dowsing will, in the years ahead, locate unknown historical treasures that were once hidden by ancient civilizations. Even discovering buried cities covered with volcanic ash. Places like the Mound Builders of Iowa, cave dwellers, and the desert sands conceal secrets just waiting to be unearthed.

Go forth and explore by dowsing to find the hidden treasures of time.

Thank you for your interest in dowsing.

With best regards, yours, Duane Arthur Ose

Written this day, November 24, 2015

Go forth and explore it by daring to dive into the hidden treasures of time.

Thank you for your interest in drawing.

With best regards, yours, Doctor Arthur Doe

Written this day November 29, 2014.

Printed in the United States
By Bookmasters